Erin Ontario in Colour Photos, Saving Our History One Photo at a Time

Photography
by Barbara Raué
2012
Updated 2017

Series Name:
Cruising Ontario

Book 169: Erin

Cover photo: 163 Main Street, Page 38

Barbara is The Authority on Saving Our History One Photo at a Time.

Book 48: London in Colour Photos
Book 53-55: Dundas in Colour
Book 87-91: Hamilton in Colour
Book 94: Oakville in Colour
Book 5: Chesley
Book 62: Stoney Creek in Colour
Book 60: Waterdown in Colour
Book 92-93: Owen Sound in Colour
Book 96: Mount Forest in Colour
Book 10: Dundalk
Book 11: Burford and Area
Book 113: Waterford and Area in Colour
Book 13: Drumbo and Area
Book 14: Sheffield and Area
Book 15: Tavistock and Area
Book 66: Ancaster and Mount Hope in Colour
Book 17: Innerkip
Book 95: Brantford in Colour
Book 61: Burlington in Colour
Book 85-86: Guelph and Area in Colour
Book 98: Ayr in Colour
Book 169: Erin in Colour Photos

Other Books by Barbara Raue

Coins of Gold

Arrows, Indians and Love

The Life and Times of Barbara
Volume 1: Inventions That Have Enhanced My Life
Volume 2: Entertainment That I Have Enjoyed
Volume 3: East Coast Trips
Volume 4: Olympics Have Always Intrigued Me
Volume 5: Wonders of the World
Volume 6: Caribbean Cruises We Have Enjoyed
Volume 7: Animals
Volume 8: Storms and Other Major Disasters in My Lifetime
Volume 9: Wars, Terrorist Attacks and Major Disasters

The Cromwell Family Book

Laura Secord Discovered

Daddy Where Are You?

Montana Series
Book 1: Montana Dream
Book 2: Life on the Montana Frontier
Book 3: Montana to Boston and Back
Book 4: Montana Sons Go to War
Book 5: Montana Sons Return From War

Visit Barbara's website to view all of her books
http://barbararaue.ca

Erin

Erin is a picturesque town in Wellington County about eighty kilometres northwest of Toronto. Erin is an amalgamated town, composed of the former Villages of Erin and Hillsburgh, and the hamlets of Ballinafad, Brisbane, Cedar Valley, Crewson's Corners, Ospringe, and Orton, as well as the former Township of Erin. There are rolling countryside, meandering rivers, small settlement areas and quaint village settings.

The first sawmill was built by the Trout family in 1826, at the lower dam at Erin. They opened a small store, and made potash, used in soap-making. The sawmill was later taken over by William Chisholm, from whom Daniel McMillan rented the mill. Daniel McMillan found that the mill cut very slowly, and decided to buy it, and rebuild it to suit himself. His father, Donald McMillan, tried to persuade him otherwise, for he was only 18 years of age, without funds. Daniel borrowed money to make the first payment, and through hard work and good planning, he was able to meet his obligations. Daniel cleared three acres of land, and renovated the sawmill which had been gutted by fire; he did the framing of the building himself. This was a much faster cutting mill, and from it, he sold lumber at four and five dollars per thousand feet.

Daniel McMillan was the man responsible for the growth of the village, assisted by his brothers, Hugh and Charles. Daniel McMillan, 1811-1849, was the oldest son of Donald McMillan and his wife, Catharine Miller, who came with their family from Scotland in 1822. They settled on lot 19, concession 9, Erin Township, and he also took up lots 14 to 17, on both sides of the 9th line. The land that became the site of Erin Village consisted of lots 14, 15 and 16.

The village of Erin is located on the west branch of the Credit River which is known for its pure cold water and trout and salmon fishing as it flows towards Lake Ontario. It joined the east branch of the Credit River at "Forks of the Credit", with the east branch finding its source above Orangeville.

Soon after the sawmill was in operation, Daniel McMillan hired a man to run it, and proceeded with plans for a grist mill which he erected in 1834 at the south-west end of the sawmill, the same power being used for both. He obtained stones for the mill from lot 12, later known as Shingler's Lime Stone Quarry, and he dressed them himself. They were said to have been 34 inches in diameter.

In 1834, Daniel McMillan built the first house in the village, east of the sawmill. In 1835, he brought his bride, Mary McLaughlin, daughter of Daniel McLaughlin of Caledon. After clearing the river flats on lots 14 and 15, the present Upper Dam was built, and here the second sawmill was built in 1838. It had new machinery and was a faster cutting mill.

Daniel McMillan built the oatmeal mill on the other side of the street, opposite the first sawmill, using water power supplied by the hand-dug race from the Lower Dam. This oatmeal mill did a good business, and was still in good shape in 1922, when it was being used as a planing mill by Mundells.

In 1838, McMillan built a grist mill at the Upper Dam. It had a large trade for about ten years. It had three run of stones, and they also made oatmeal. It did good work with dry wheat, but not if the grain was damp. This building became a woolen mill.

In 1845, Daniel McMillan had a large stone house built. It was the family residence for twenty years. Then it was sold to William Chisholm, and it became the Globe Hotel, until it was destroyed by fire in January 1945.

In 1847, Daniel McMillan decided to build a more up-to-date grist mill, or flouring mill, that would meet the needs of the fast-growing community.

Erin Village expanded rapidly through the 1840s. Lumbermen and millers enjoyed favorable tariff with the United States when wheat was brought from the States to Canada where it was processed, then shipped to Britain. This increased demand for flour was the reason Daniel McMillan built his new grist mill, which he planned to have in operation by Christmas, 1849.

A surveyor was engaged to choose the best location, the site where Bell's Mill stood in 1922. Stone masons were brought from the Old Country; the race known as the "Big Ditch", brought water from the Upper Dam. The building was to be six storeys high. There were 200 men at the raising, and it took three days to erect. Everything went according to schedule. The intricate machinery was put into place. When Daniel McMillan went to Toronto for the mill stones, he was accompanied by his brother, Hugh, and his best friend, John Rott (Root), in whose Conestogo wagon the mill stones were brought to Erin.

On December 14th, he got a sliver in one of his fingers, but no attention was paid to it at the time. However, blood-poisoning developed, and he died in great agony three days later, on December 17, 1849, at the early age of 38 years. The Mill was finished on December 22nd, but the hero did not live to see his dream come true. This mill became the Co-Op Building.

Daniel McMillan was a man of tremendous energy and planning ability; and in the short period of eighteen years in Erin Township, he achieved more than most men do in a lifetime. He was a leader, and had established his village on a firm footing. But without its leader, the village had lost its sense of direction.

Alexander McLaughlin, the great Canadian Poet, and life-long friend and admirer of Daniel McMillan, wrote a long poem about him, expressing very effectively, his great loss to the Erin community. Title of the poem: "A Backwood Hero", is an In Memoriam. This is the first of ten verses.

> Where yonder ancient willow weeps,
> The father of the village sleeps;
> Tho' but of humble birth,
> As rare a specimen as he,
> Of Nature's true nobility, As ever trod the earth,
> The busy head and hands are still;
> Quenched the unconquerable will
> Which fought and triumphed here;
> And tho' he's all unknown to fame,
> Yet grateful hearts still bless his name,
> And hold his memory dear.

Reference is made to his planning and assistance in building roads, schools, churches, mills, a store, forge, vat, and kiln. He seemed to be doctor, lawyer, judge, surveyor, and was never too busy to lend a helping hand.

In 1838, Daniel had encouraged William Cornock to locate in the village. Cornock built a distillery that continued in operation until 1860. Mr. Cornock also operated the first dry goods store, and secured a Post Office for the village. A lime quarry was opened by James Shingler. S.L. Shotter opened the first general store on the corner that was occupied by the Post Office in 1922.

North of Shotter's store, Daniel McMillan erected a building known as the cooperage, where he and his brothers worked on wet or stormy days. They made barrels for flour, tubs, churns, wooden pails, wooden pumps, etc., which were much in demand by the early settlers. They also made coffins.

In 1839, Erin Post Office was opened under the name of "Macmillan's Mills". In 1851, the name was changed to "Erinsville". The village had 300 people, two grist mills, two oatmeal mills, a distillery, a carding and fulling mill, a tannery, and a church with free use to all denominations. Agricultural prosperity and abundant water power stimulated the community's growth as an important regional centre for milling and the manufacture of wood products. In 1879 a branch of the Credit Valley Railway was completed through Erin to Toronto.

Erin is primarily a rural community but, while farming is still an important activity in the town, most of its population works in the nearby cities of Brampton, Mississauga, Guelph, and Toronto. Wander the beautiful downtown, enjoy the shops, and find unique treasures that are great for gifts. Erin boasts an eclectic array of shopping with everything from housewares and home décor, to clothing and toys. Country living meets boutique shopping in this beautiful village.

Alexander McLaughlin, 1820-1896, was born in Glasgow, Scotland, and came to Canada at the age of twenty. He lived for a time in Peel County and in Perth County, and then bought property in Erin Village where he had a tailoring shop for twenty years. He was a noted Gaelic Poet, and spent much time writing poetry, lecturing and entertaining. During his life time he published several volumes of poetry: The Spirit of Love, 1846; Poems, 1856; Lyrics, 1858; The Emigrant, 1861; and Selected Poems, in two volumes, the second being in preparation when he died.

He was a man of striking appearance, and was well built. He was good company, full of anecdotes and repartee, and was well educated.

In 1862, he became a government lecturer and immigration officer for Scotland. He made a tour of Scotland, describing the wealth and resources of Canada; and as a result thousands of settlers came from Britain in the following years.

McLachlin lived for seventeen years in Amaranth Township which was a part of Wellington County at that time. He and his daughters moved to Orangeville where he died in 1896, and was buried in the family plot at Forest Lawn Cemetery.

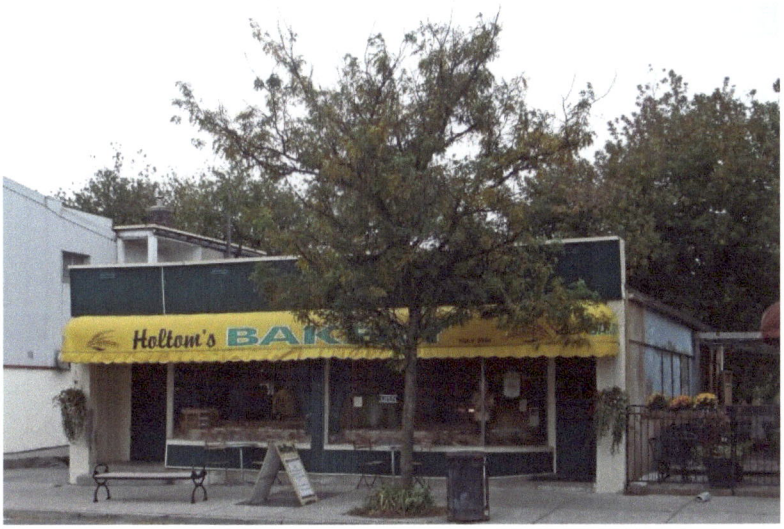

78 Main Street - Holtom's Bakery – a favourite place to stop on the way through town

This family business has been serving Erin for several generations since 1946. They have an excellent selection, providing fresh baked foods from assorted breads through to tasty sweets.

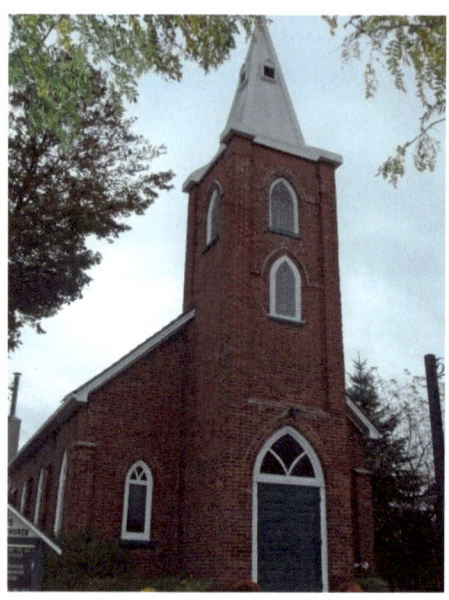 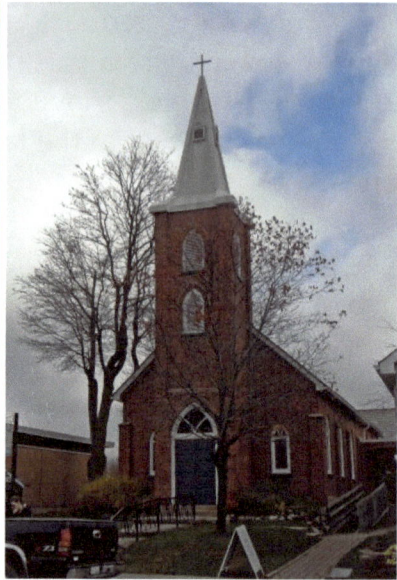

81 Main Street – All Saints Anglican Church is a brick building built in 1867 on land donated by a prominent local businessman and politician, William Cornock, after the closing of a distillery that he owned. The bell tower was added in 1910. The Women's Auxiliary was formed in 1895 and continued vital work in supporting and organizing church life. The prominent white spire to top off the bell tower was added in 1995. For many years, the Anglican Church bell served as a fire warning. Gothic Revival – lancet windows

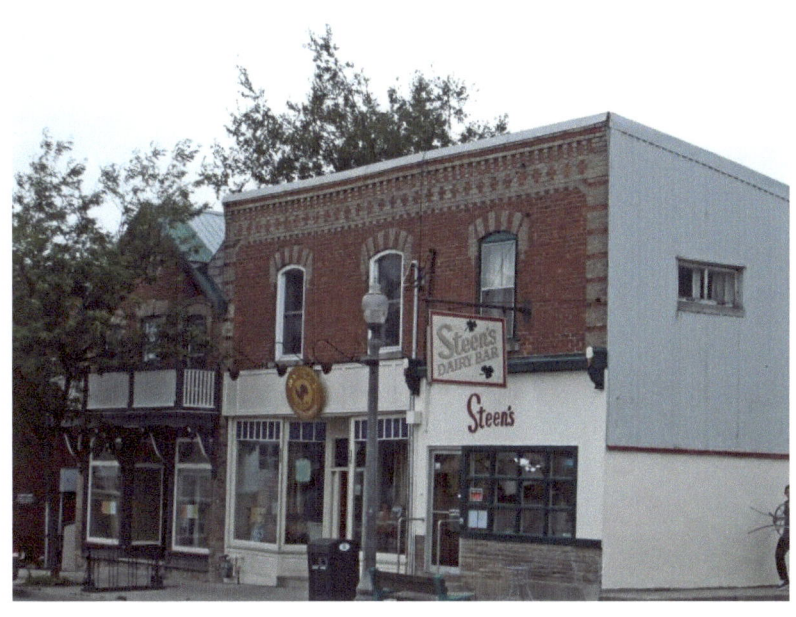

Steen's Dairy Bar is the only privately-owned dairy in Wellington County, and is one of only a handful of privately-owned dairies in Ontario. Fred Steen purchased the business in 1945, from a Grand Valley man who established it. It continues to serve communities within a 75-mile radius. Fred Steen was a brother of Mrs. Mel Barden of Hillsburgh.

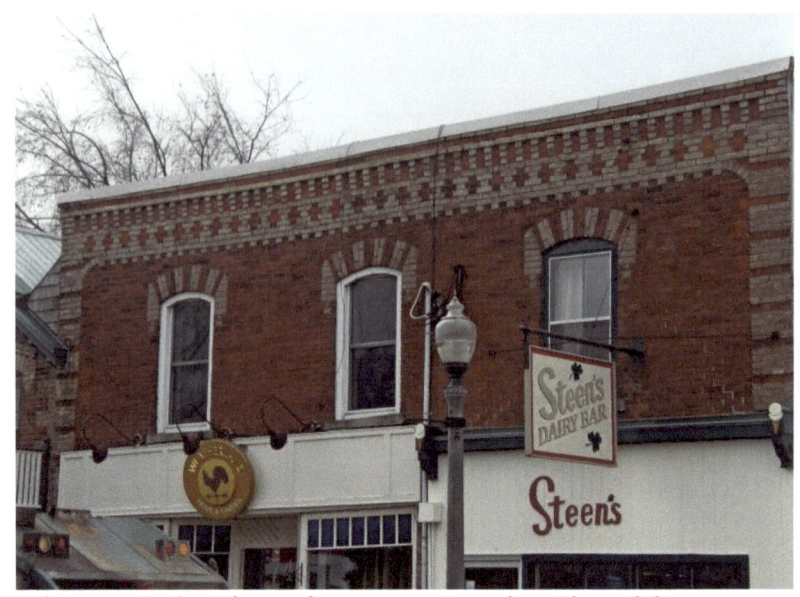

Dichromatic brickwork, voussoirs, dentil molding, corner quoins

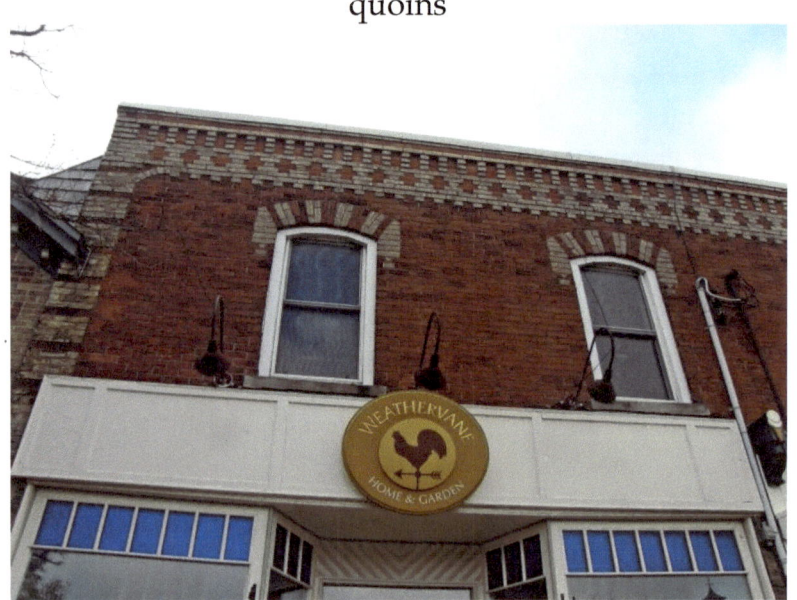

74 Main Street – Weathervane Home & Garden for gifts and home and garden accents – dichromatic brickwork and voussoirs

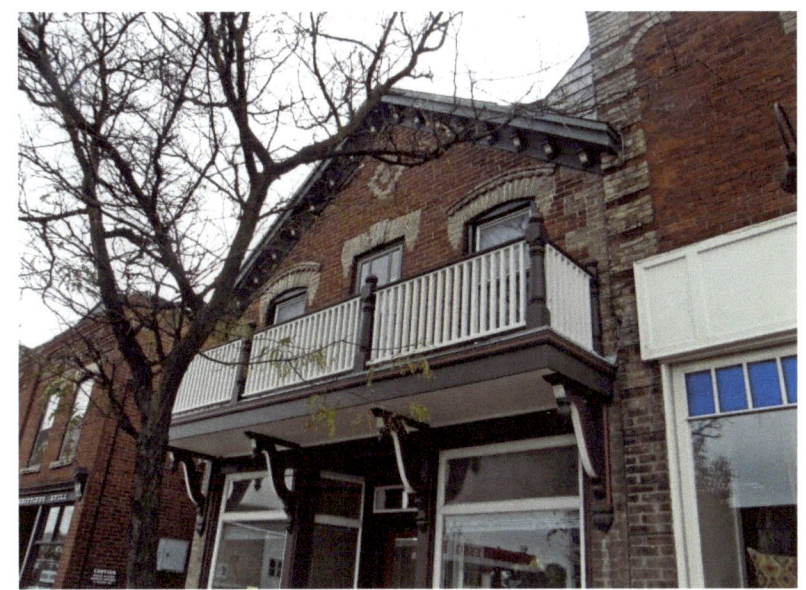

Gothic – dichromatic brickwork, voussoirs and keystone, corner quoins

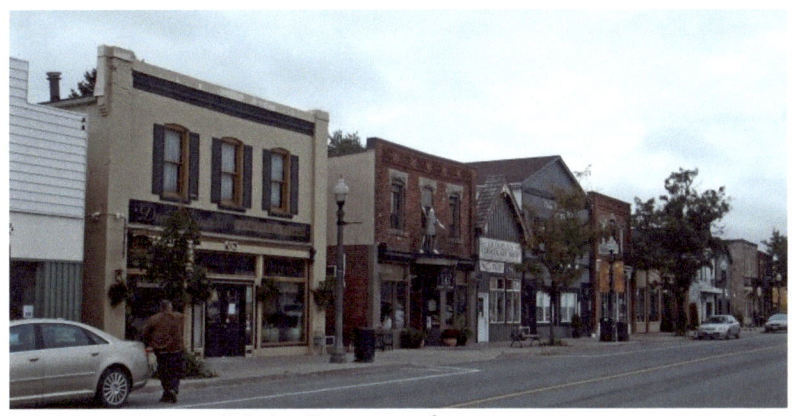

Main Street – downtown

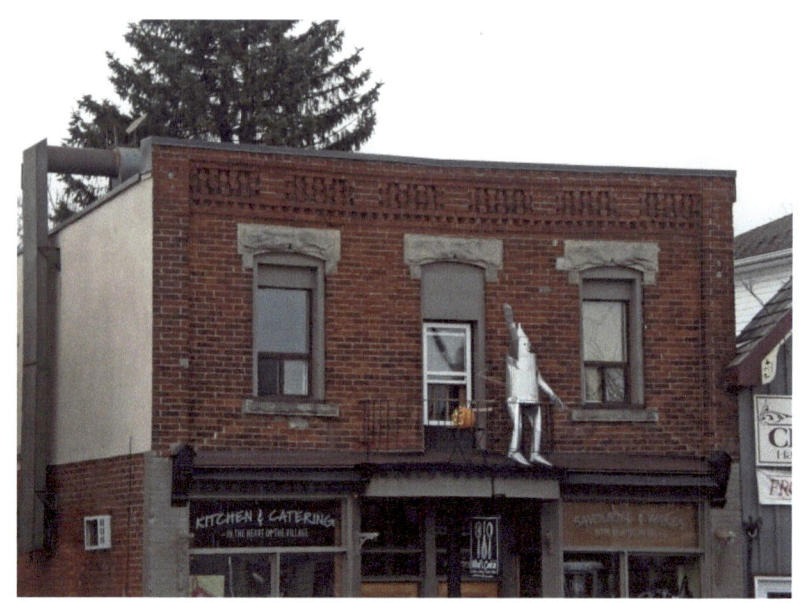
"The Tin Man"

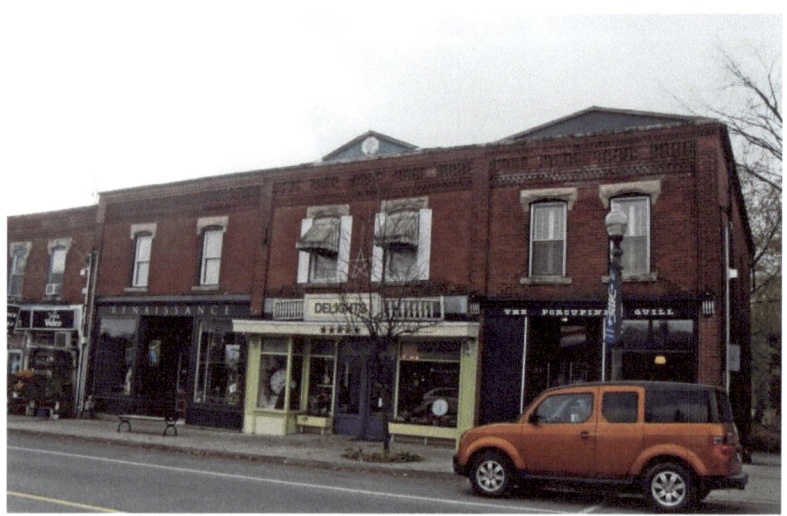
Downtown

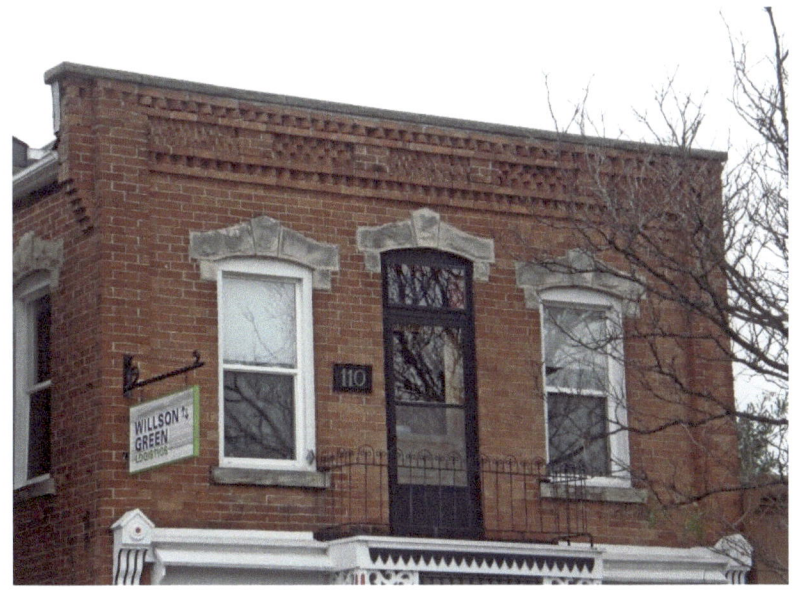

110 Main Street – saw tooth molding

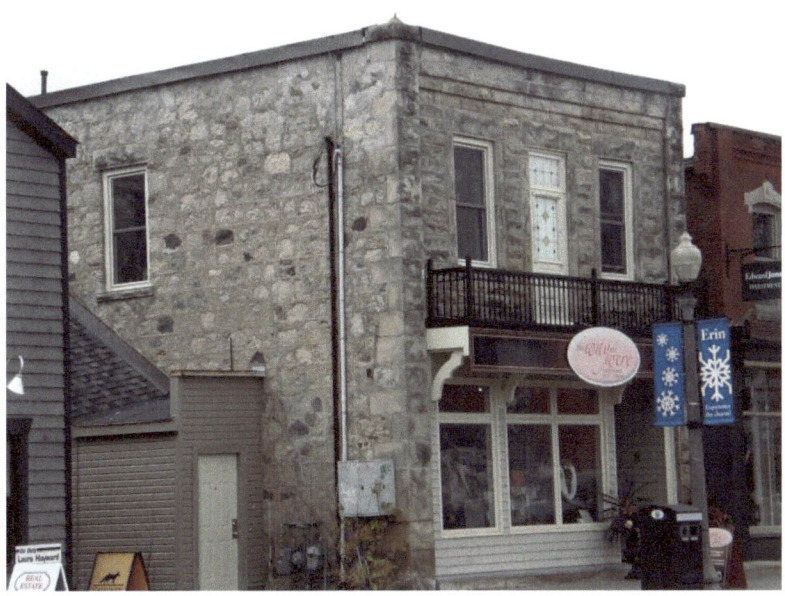

Cobblestone

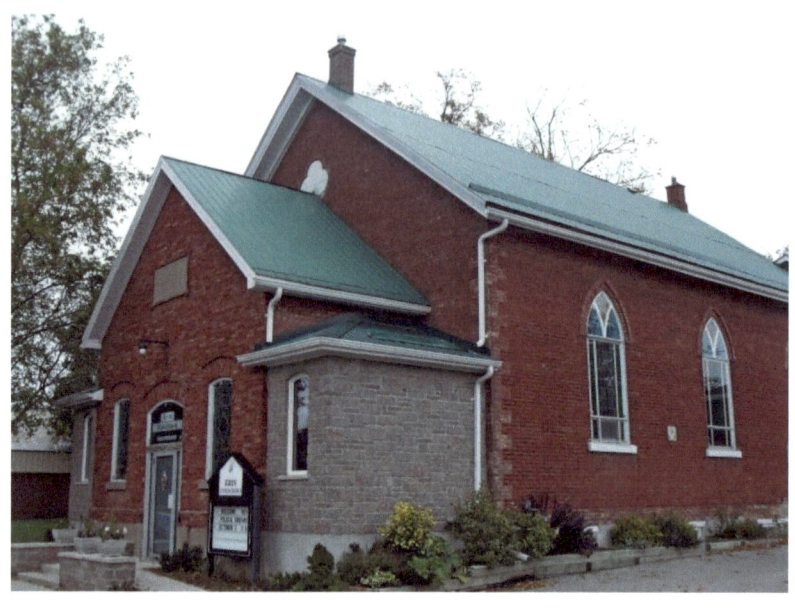

115 Main Street - The Wesleyan Methodists built an eight-sided church on the present site of the United Church, but it was destroyed by fire in July 1870. It was rebuilt, and was officially opened in January 1871. It continued as the Methodist Church in Erin, until 1925. The Methodist Church became Erin United Church in 1925. A new entrance and vestibule were built, giving more space in the Church Auditorium. The shed for horses and rigs was torn down at the back, leaving space for a new kitchen, washrooms and Christian Education Wing, the latter added in 1958. Gothic Revival style – lancet windows, corner quoins

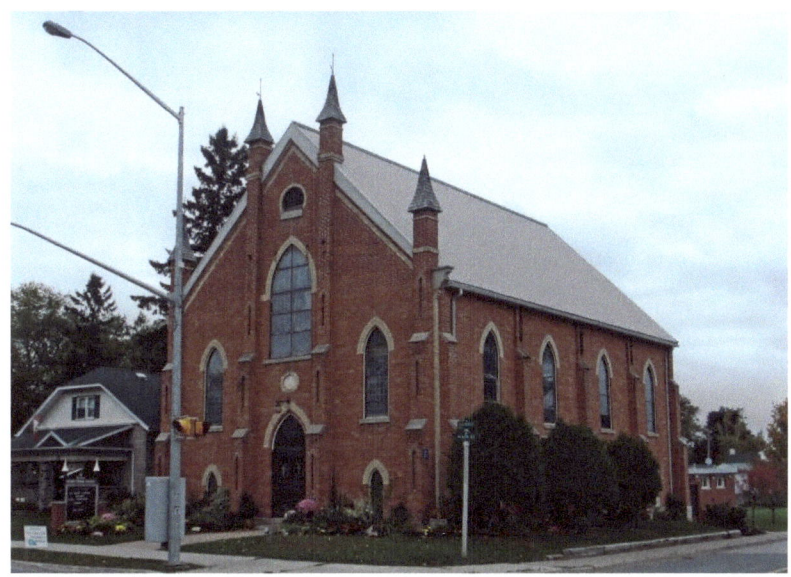

155 Main Street - Burns' Presbyterian Church was built in 1881. In 1925, members voted in favor of remaining Presbyterian. In 1952, a new organ was installed, and in 1965, beautiful stained glass windows were given by members In Memory of their loved ones. Gothic Revival style – lancet windows, buttresses with finials

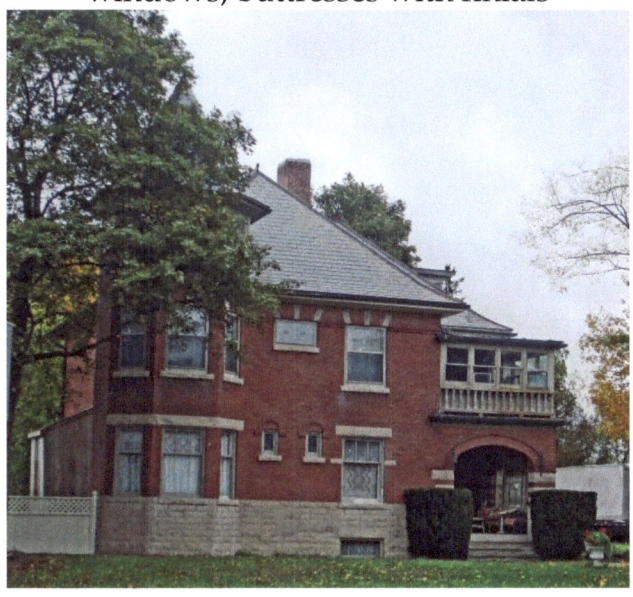

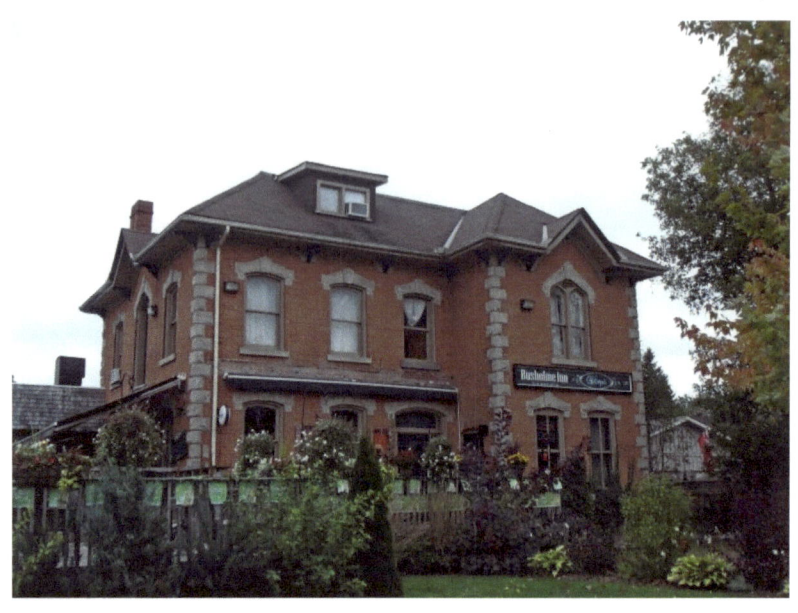

156 Main Street - The Busholme Inn at the corner of Main and Church Streets was the home of J.P. Bush and family. It was built circa 1886 by Dr. McNaughton, as a hospital, but was never used for this purpose. In 1893, Dr. Martin owned the large house, then Dr. J. Hamilton, and several other doctors. In 1926, Dr. Reynolds sold to J.P. Bush and it became a hotel. Mrs. McKenzie purchased it in 1930, and in 1967, it was owned by Matt Fullerton of Brampton and T.B. Cooper of Toronto. Now it is the Jolly Rogers' Restaurant. It is in the Italianate style with a hipped roof, dormer, two-storey frontispiece, and corner quoins. The arched lintels with a central keystone were made with sandstone from the Credit Forks quarry.

Erin school was the second school opened in the Township, and became S.S. #2. First school for Erin Village was built on lot 18, concession 9, on the lot that later became McMillan's Burying Ground. This school was also used as a church for some years. Since the settlement developed to the south, a small frame school was erected in a more central location, on lot 15, concession 9, on the Conboy property. Another school was built on the site of the Baptist Church, later the property of Mrs. Fred Bingham.

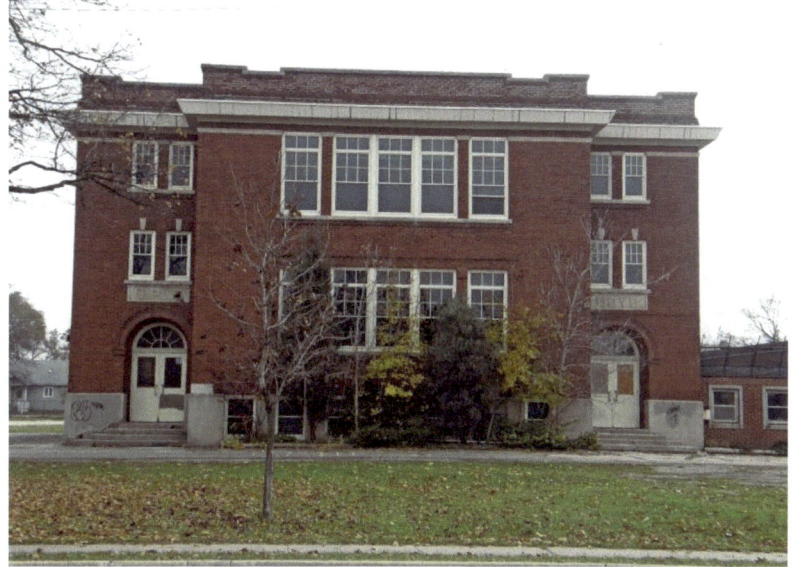

The Erin Pioneer and Continuation School – c. 1854

In 1854, the stone school was built on the David Mundell property. At first it was one room, later two rooms. The first teacher was William Firstbrook. Three-quarters of an acre was purchased from the estate of D. McMillan, at the rear of the Union Church (now Presbyterian) for a house and garden to be used by the teacher.

In 1924, the new Continuation School was opened and in 1926, it was up-graded, offering all grades from 9-12. Until 1951, Erin had a Continuation School, housed upstairs in the Erin Union Public School on Main Street. In 1944, it was considered a small school, and the Department of Education urged such small schools to close. Erin Village fought against this, circulated petitions and sent delegations to the Department. The community was successful, and established Erin District Board.

In 1951, the name was changed from Erin Continuation School, to Erin District High School, and immediately they began to look for a separate location for a new school. In February 1954, seven acres were purchased on Daniel Street, and a four-room building was opened for the 1955-56 term. Four rooms were added in 1958. Another four classrooms were added in 1963, along with offices, foyer, and gymnasium/auditorium.

In 1974, Erin High School was again in danger of being closed, but finally the new addition made space for Industrial Arts, Family Studies, Music, Art, a Resource Centre, more offices, a gym and cafeteria, biology lab, and an "Open Concept" on Second floor.

In 1975, the Second Floor was changed to six classrooms; and since 1975, several Portables have been added. The County Board system was introduced in 1969.

For the 1955-56 school year, there were 115 students, with three teachers and a Principal. In 1974, there were 729 students with 40 teachers. In the 1995-96 term, there were 653 students, the Principal, Vice-Principal and 48 teachers.

The 40th Anniversary of Erin District High School was celebrated on May 10-11, 1966, with a School Reunion.

1 Ross Street - dormers

4 Ross Street – verge board trim on gable

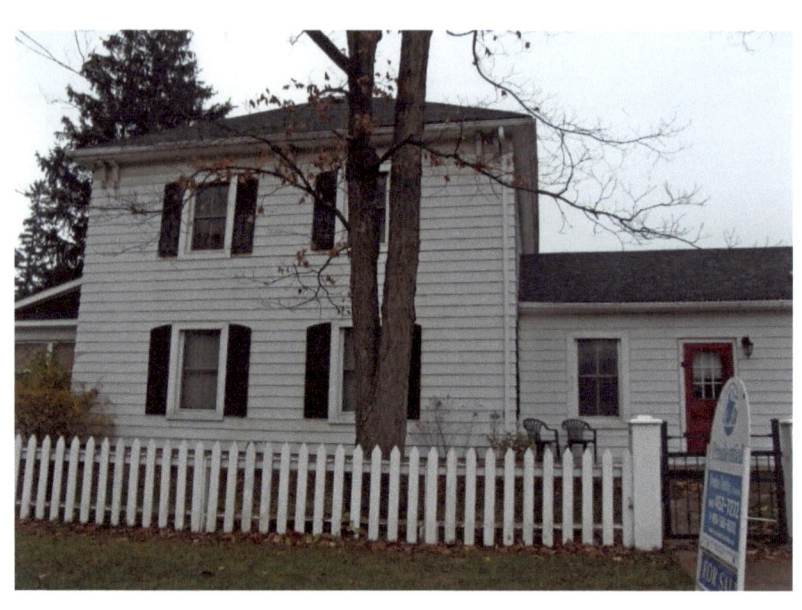

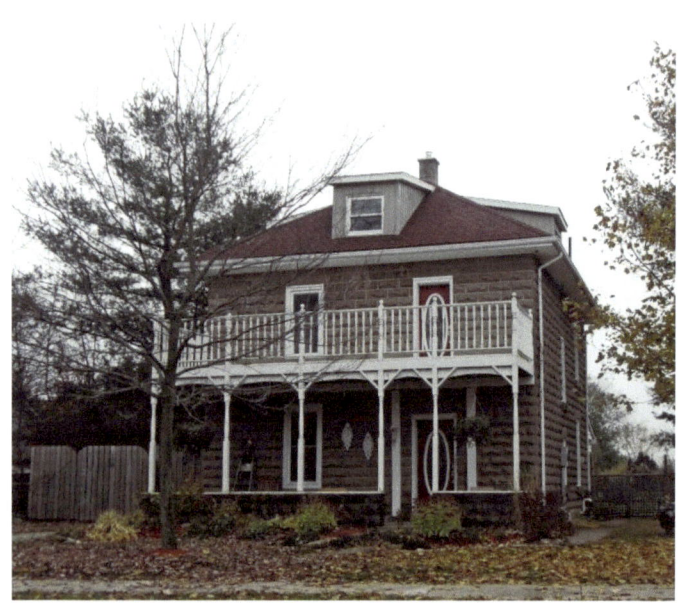

Dormers, second floor balcony

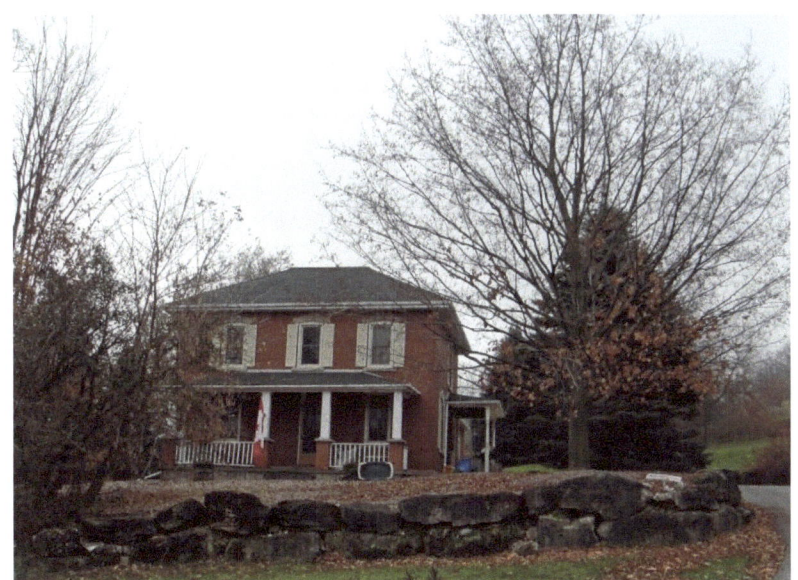

#50 – hipped roof

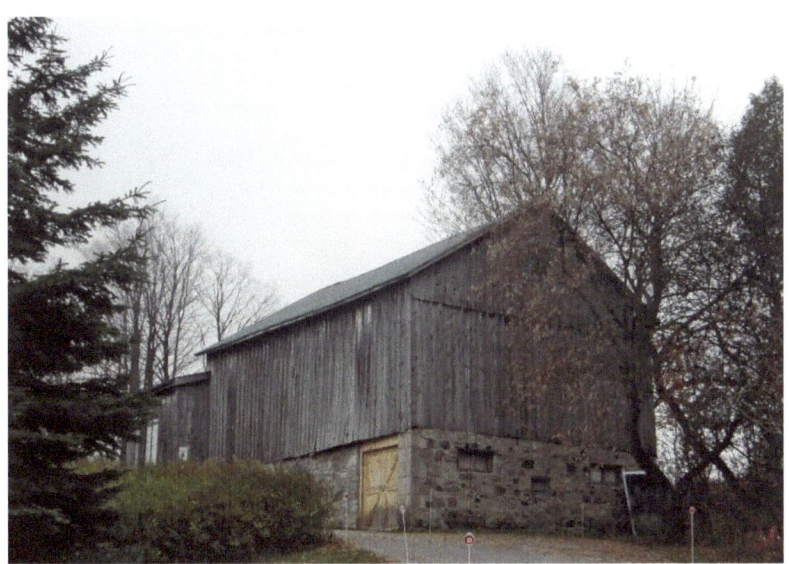

Cobblestone foundation

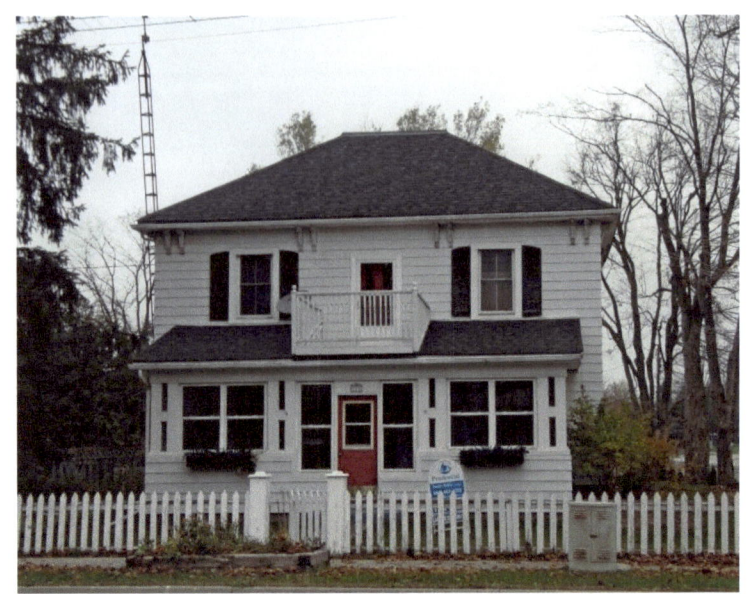

219 Main Street – hipped roof, balcony above enclosed porch

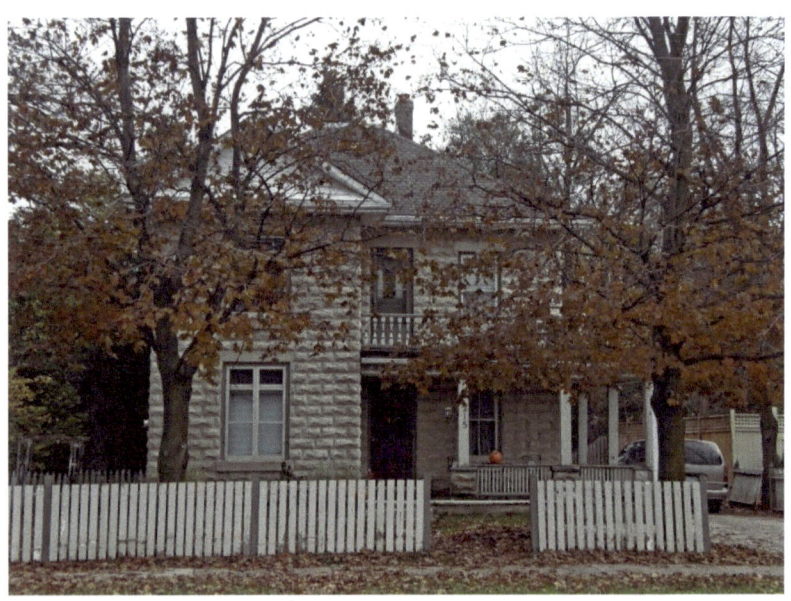

215 Main Street

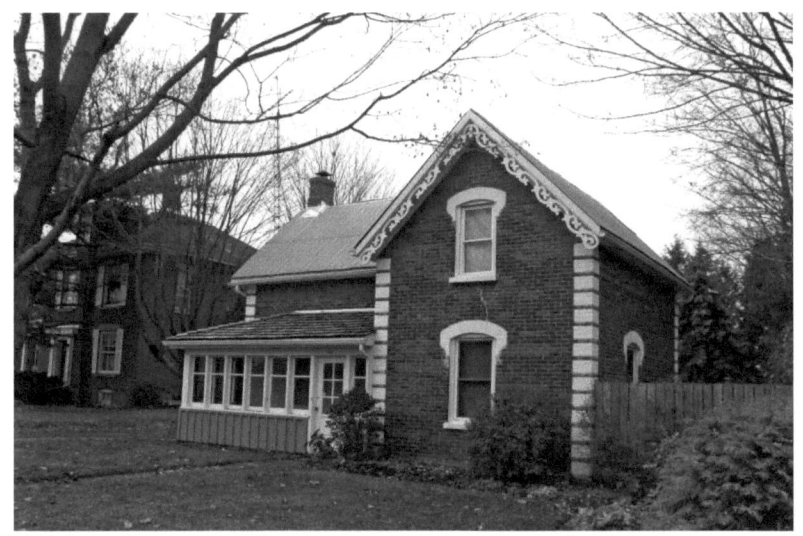

214 Main Street – Victorian - gingerbread trim, contrasting white corner quoins

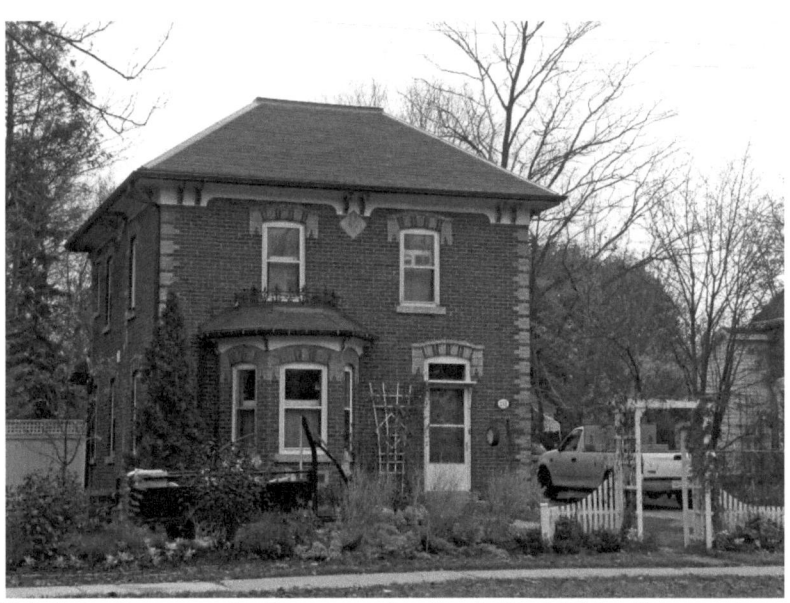

213 Main Street – Italianate - built A.D. 1891 – hipped roof, paired cornice brackets, iron cresting above bay window, dichromatic brickwork

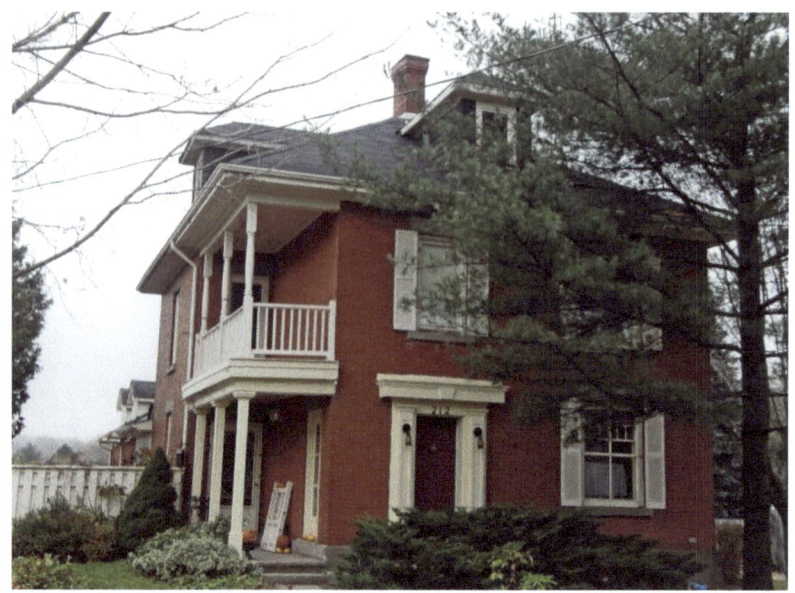

212 Main Street – dormers in hipped roof, second floor balcony

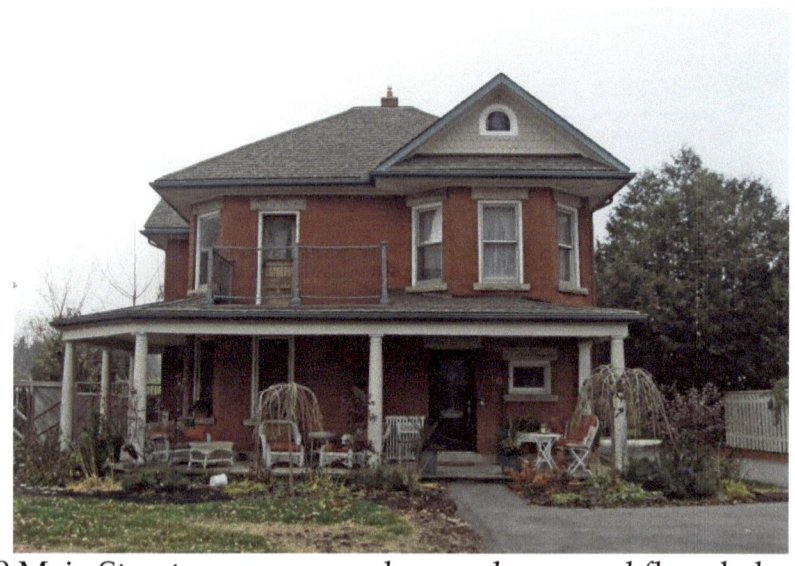

210 Main Street – wraparound veranda, second floor balcony, and bay window topped with a gable

Red brick

208 Main Street – belvedere and dormer on hipped roof section; Gothic wing

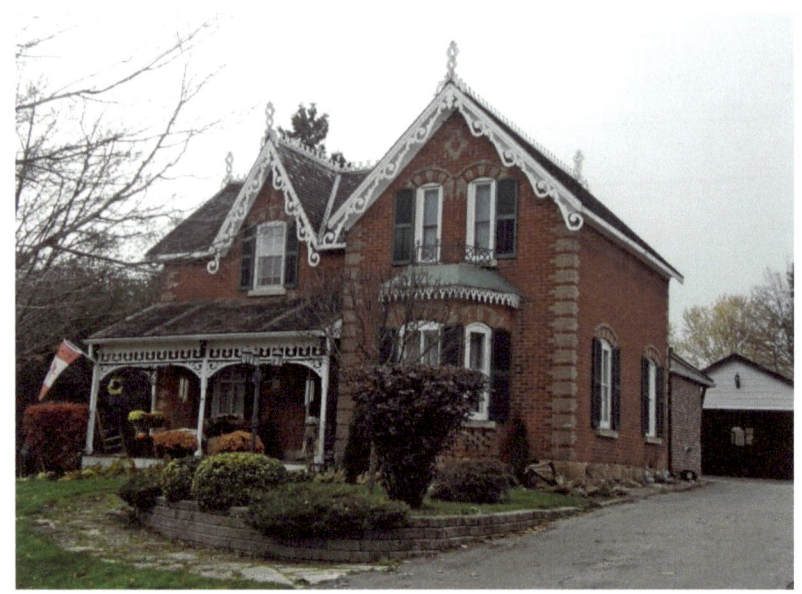

202 Main Street – Gothic Revival – late 1800s - verge board trim and finials on gables, bay window, corner quoins, dichromatic brickwork

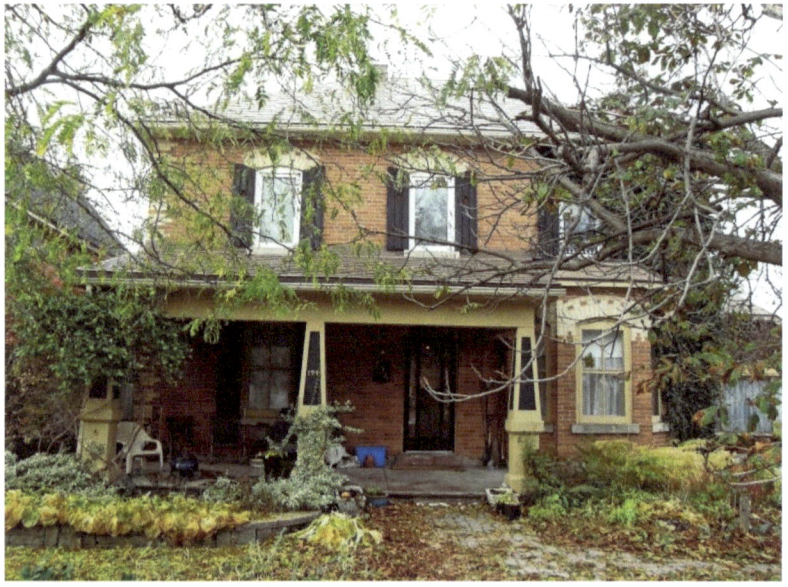

194 Main Street – hipped roof, decorative dichromatic voussoirs

192 Main Street – cobblestone, Gothic style arches with gingerbread trim

15 Scotch Street - corner of Main Street – hipped roof – Hair Salon

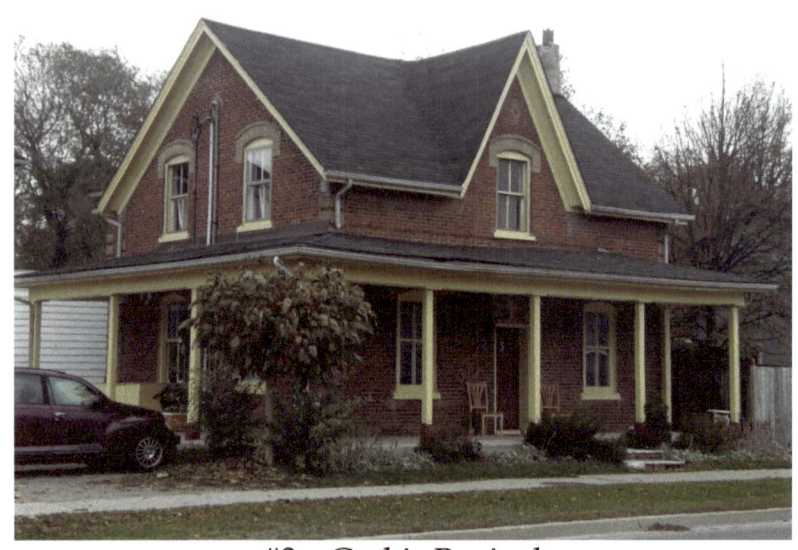

#3 – Gothic Revival

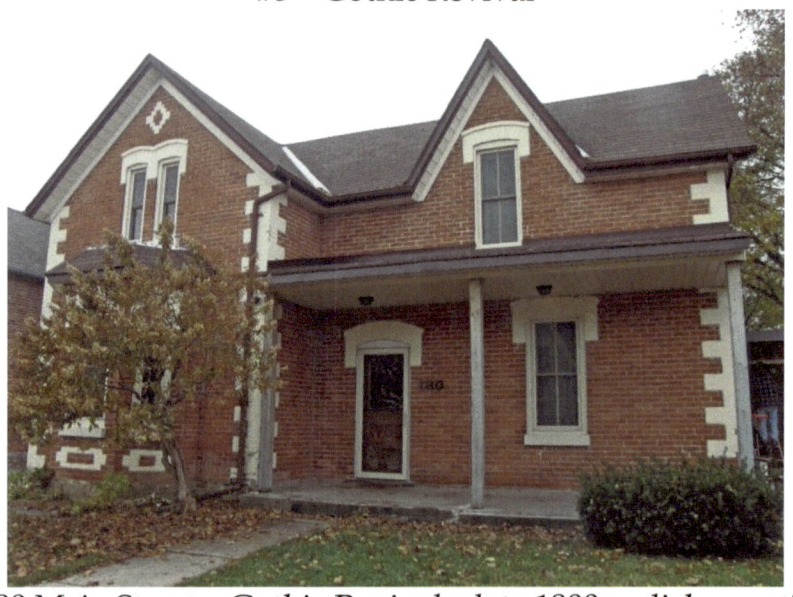

180 Main Street – Gothic Revival – late 1800s - dichromatic quoins, voussoirs and brickwork patterns

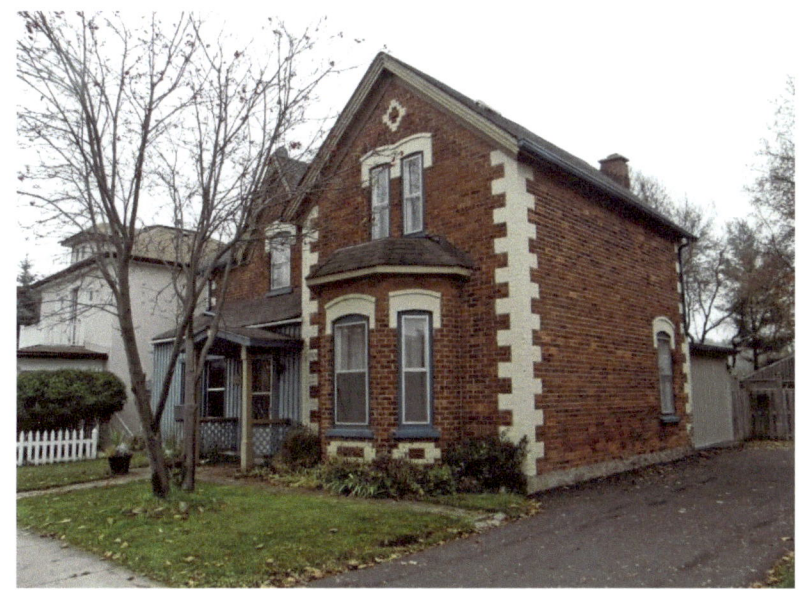

178 Main Street – bay window, dichromatic corner quoins voussoirs and brickwork patterns

Main Street – vernacular, dormer

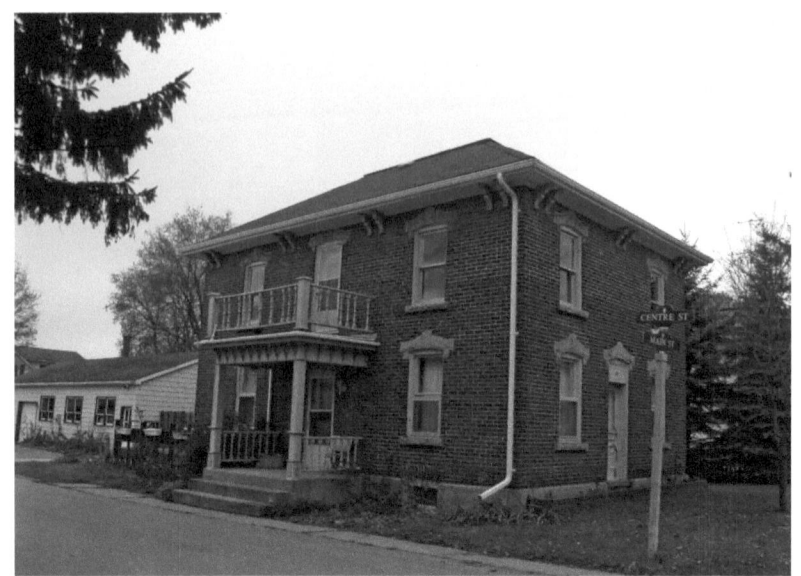

Corner of Centre and Main Streets – Italianate - hipped roof, paired cornice brackets, voussoirs with keystones

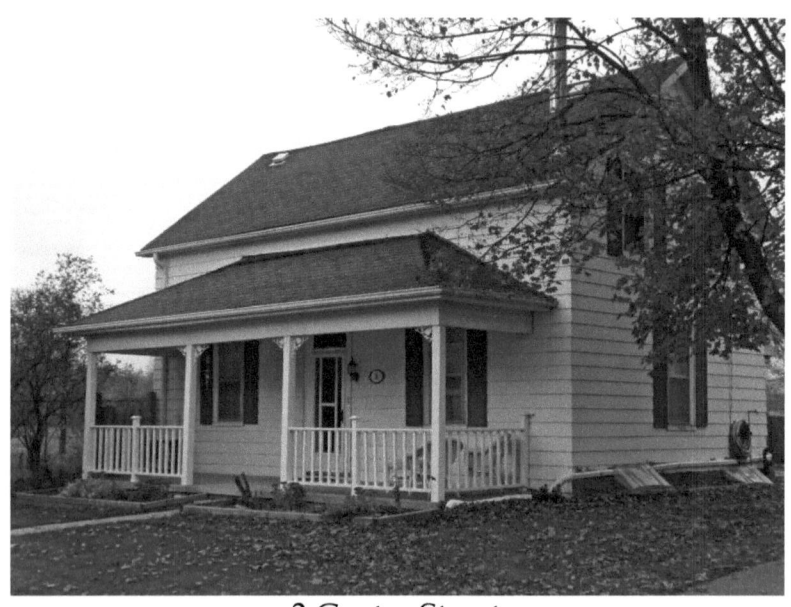

3 Centre Street

2 Centre Street

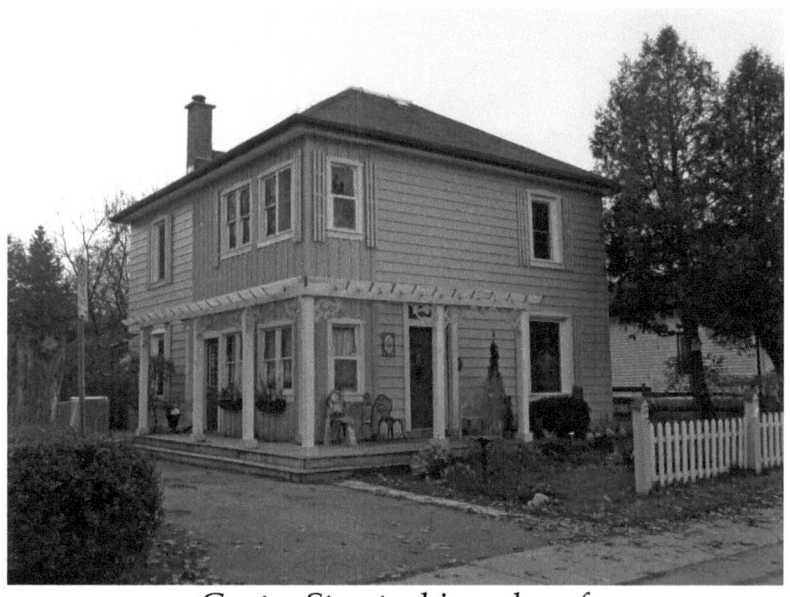

Centre Street – hipped roof

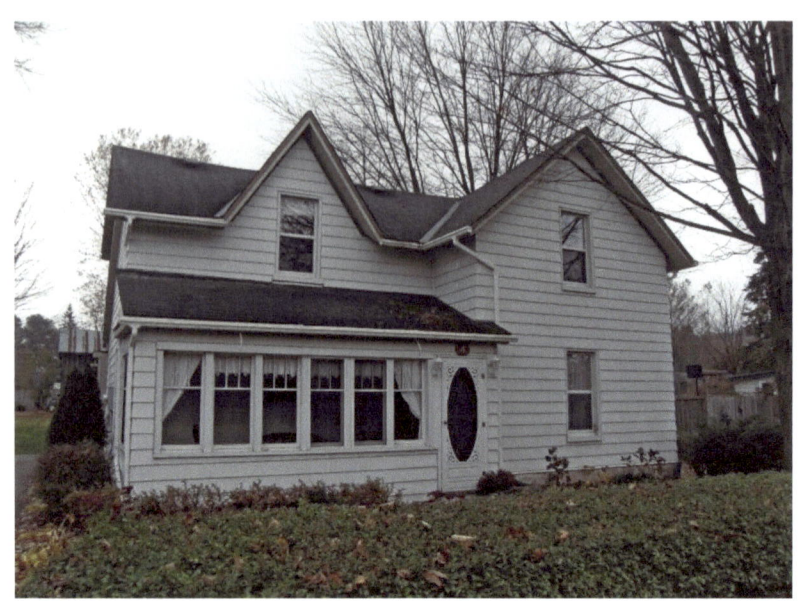

4 Centre Street – Gothic style

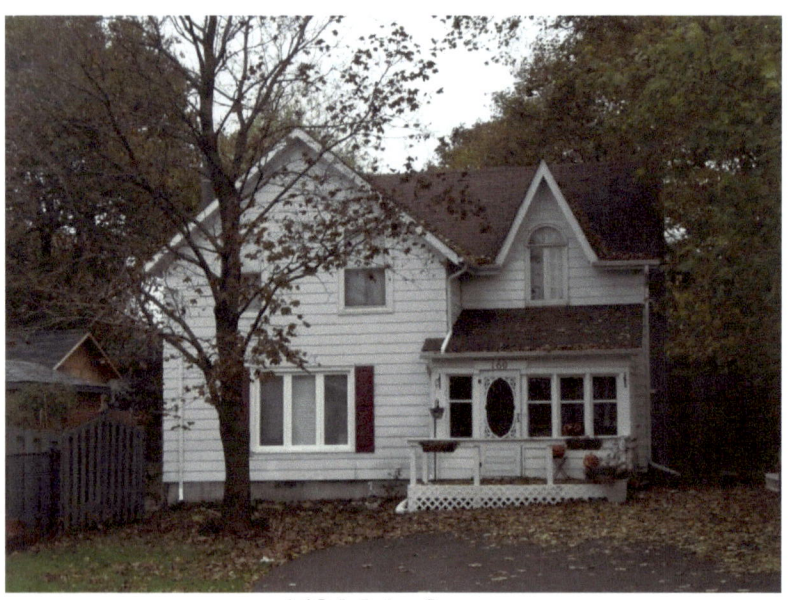

169 Main Street

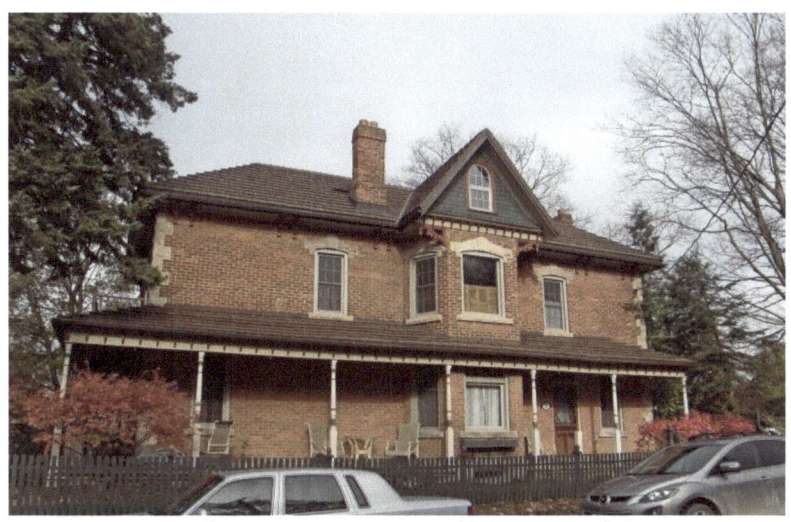

2 Spring Street - house at corner of Main and Spring Streets, built in 1896 by Ben Mundell. Later it was the Overland home. Turned spindles for wraparound veranda supports; corner quoins, 2½-storey tower like bay

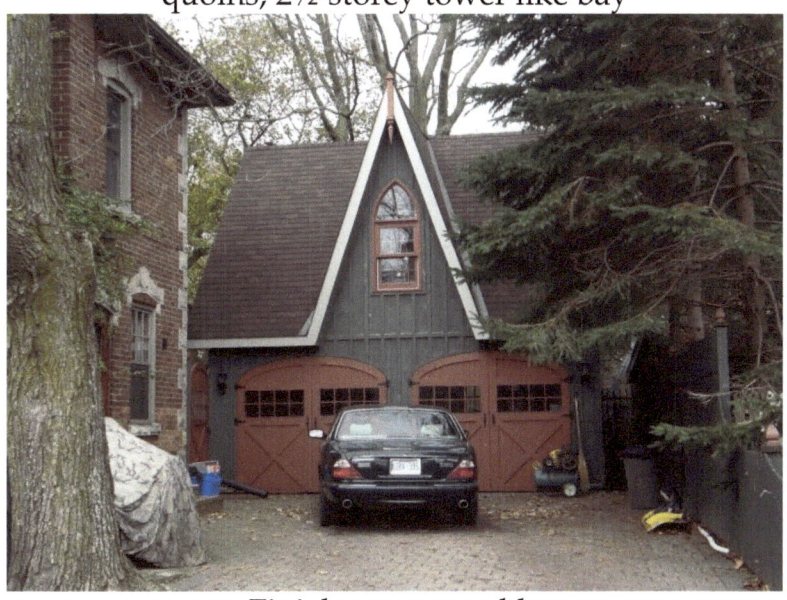

Finial on steep gable

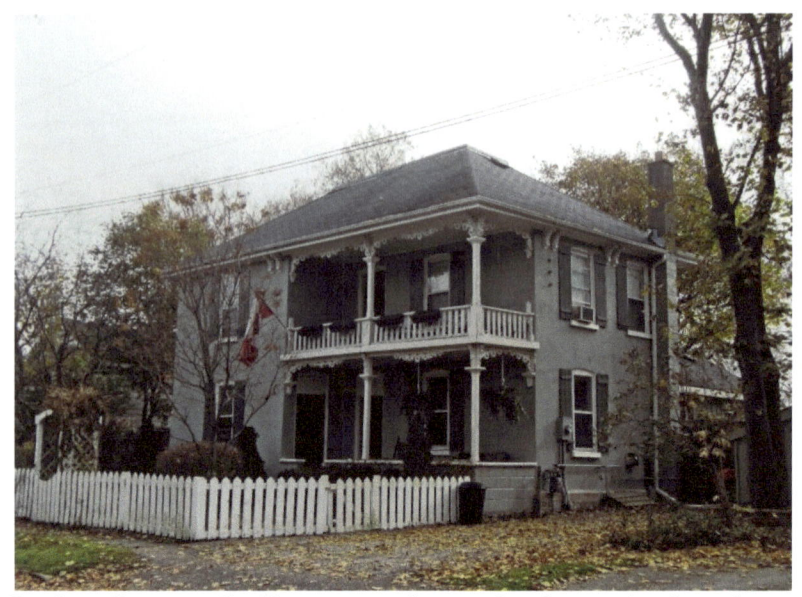

Spring Street – Italianate style - paired cornice brackets, second floor balcony with bric-a-brac detailing above the capitals on the support pillars

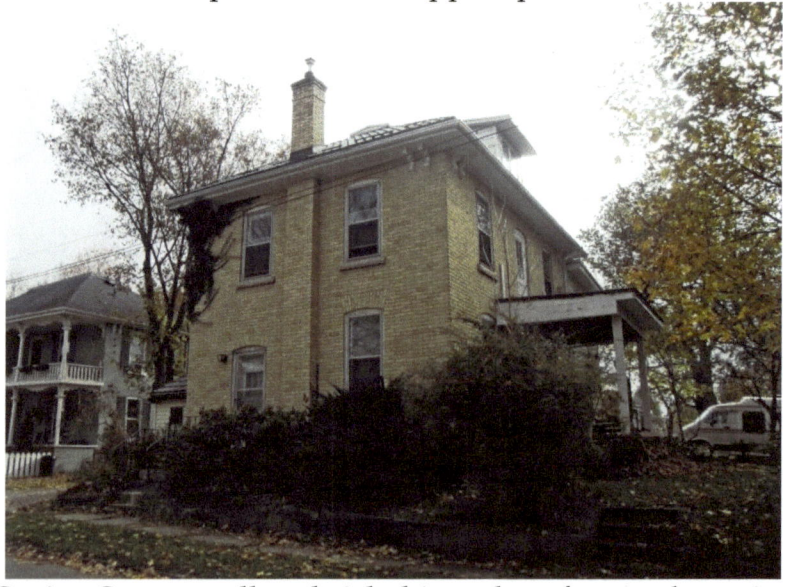

Spring Street - yellow brick, hipped roof, paired cornice brackets

Spring Street - circa 1890

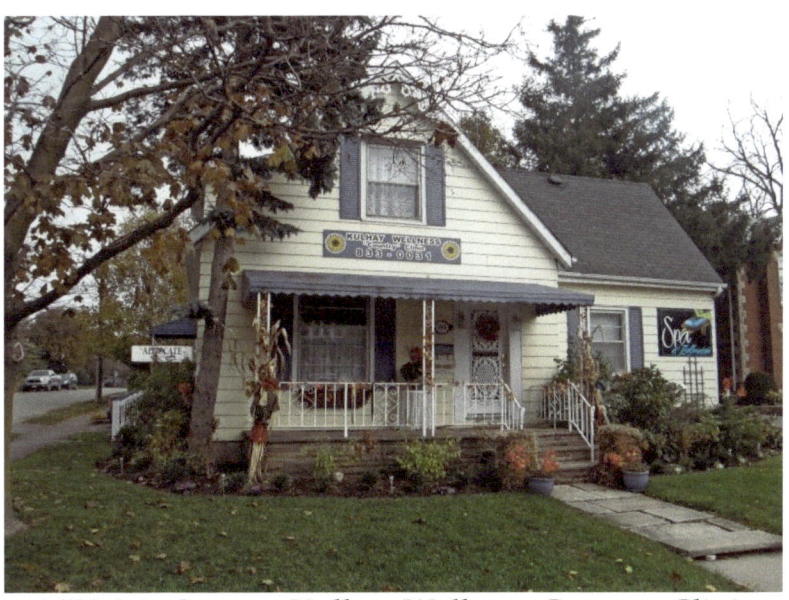

165 Main Street – Kulhay Wellness Country Clinic

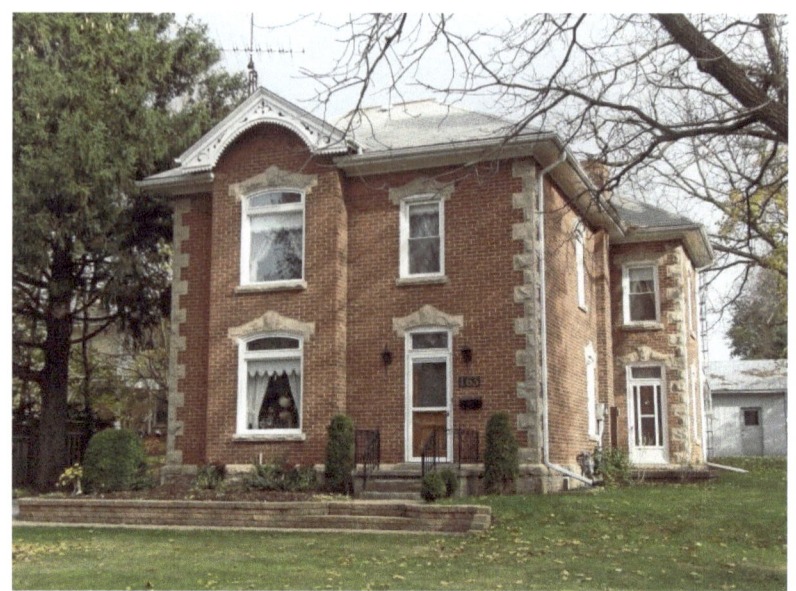

163 Main Street – Italianate – two-storey frontispiece with bargeboard trim on gable; corner quoins, stained glass transom windows on doors and some windows

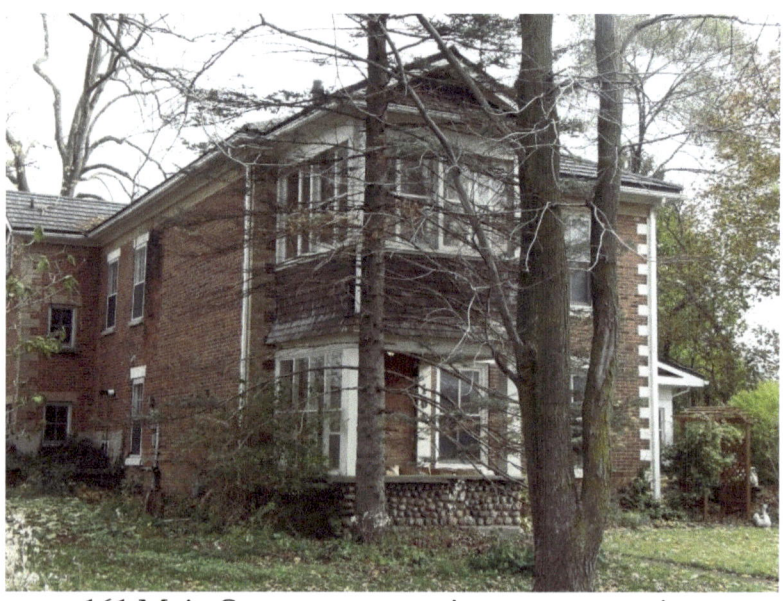

161 Main Street – contrasting corner quoins

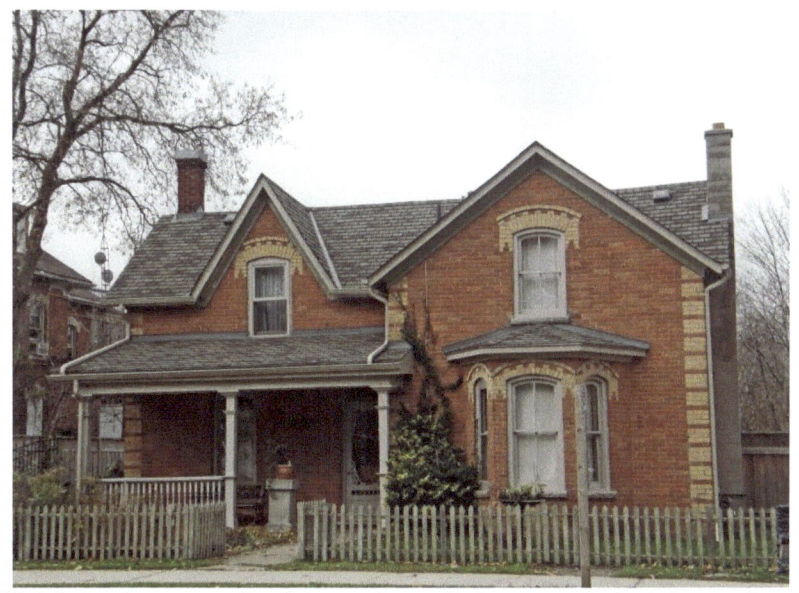

158 Main Street – Gothic style – dichromatic brickwork and quoins, bay window

157 Main Street – chipped gable, dormer on side, cobblestone veranda, pediment

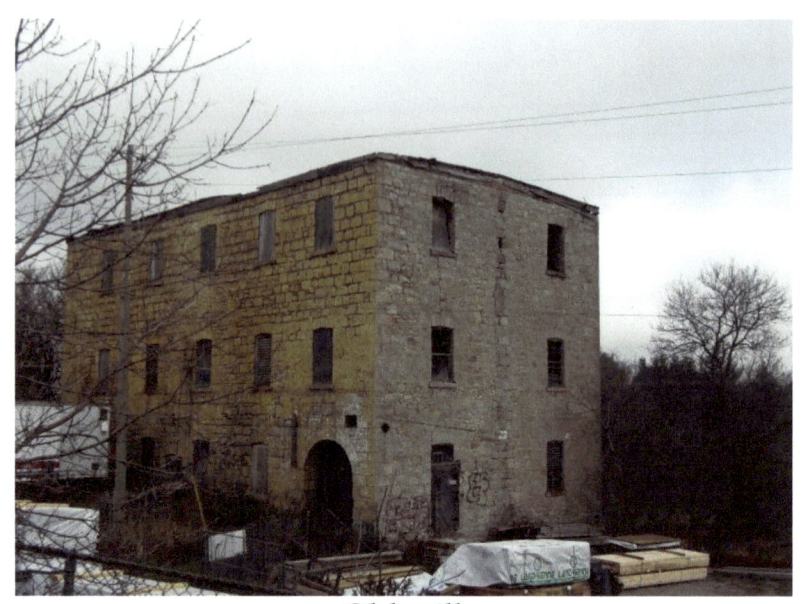

Old mill

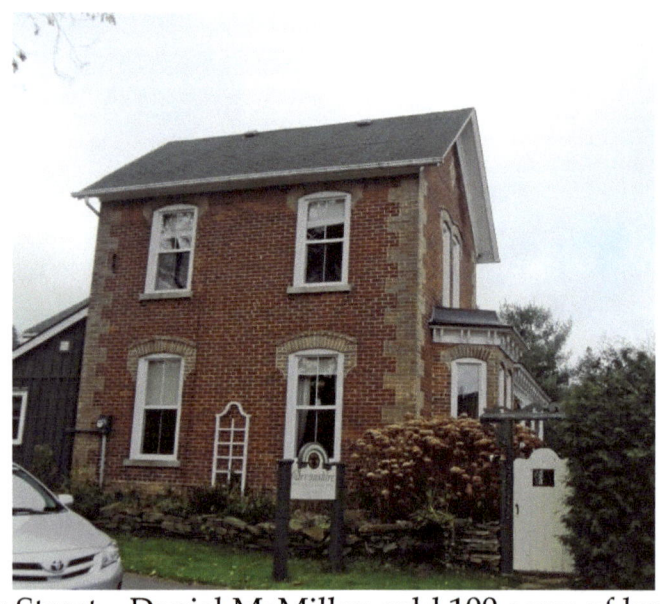

3 Union Street – Daniel McMillan sold 100 acres of land to his brother Charles who built this early brick house in 1856. Devonshire House and Spa – dichromatic brickwork

Old ambulance

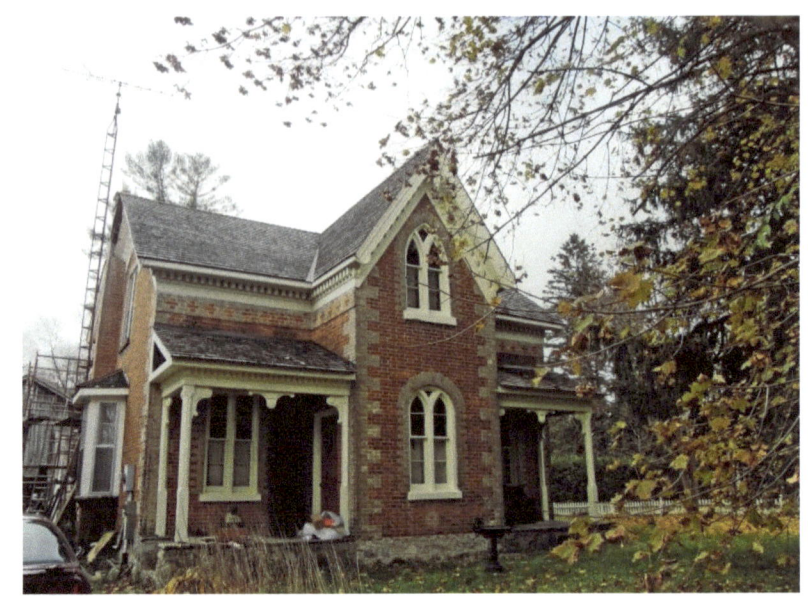
Dichromatic brickwork, dentil work under eaves, quoins

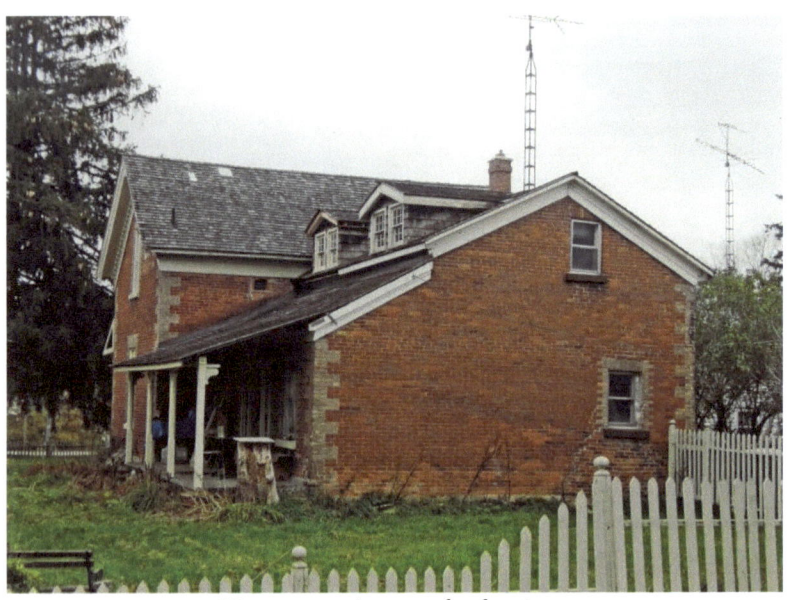
Dormers in roof of wing

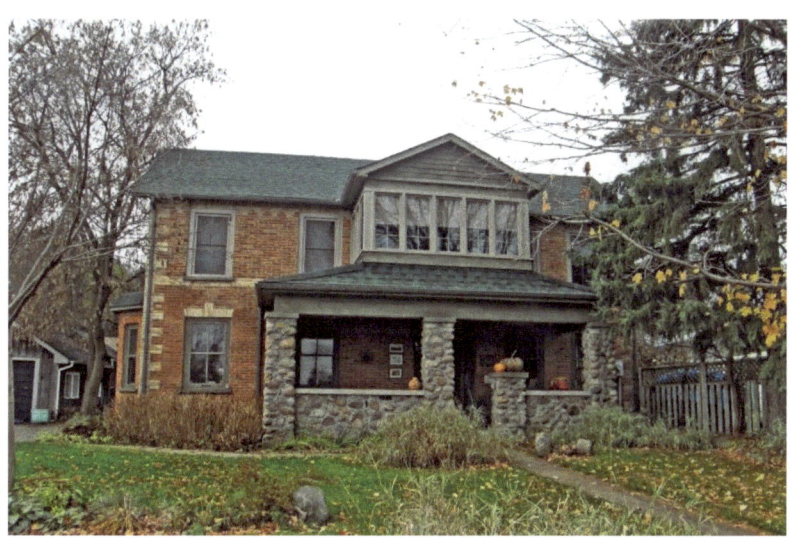

#30 – cobblestone veranda, corner quoins

Architectural Terms

Bay Window: A window that projects out from a wall, in a semicircular, rectangular, or polygonal design. Used frequently in Gothic and Victorian designs. Example: 213 Main Street, Page 25	
Belvedere: (from the Italian "beautiful view") an architectural feature on a roof, in a garden or on a terrace that gives a beautiful view. Example: 208 Main Street, Page 27	
Brackets: a decorative or weight-bearing structural element which forms a right angle with one side against a wall and the other under a projecting surface such as an eave or roof. Example: Corner of Centre and Main Streets, Page 32	
Buttress: a masonry structure built against or projecting from a wall which serves to support or reinforce the wall. In Canadian architecture, they are sometimes used for decoration. Example: 155 Main Street, Page 17	
Cobblestone architecture: Refers to the use of cobblestones embedded in mortar as a method for erecting walls on houses and commercial buildings. Example: barn, Page 23	
Dentil Moulding: an even series of rectangles used as ornamental decoration in cornices. Example: Page 42	

Dichromatic brickwork: the use of two colours of brick, tile or slate to decorate a façade. Example: Page 12	
Dormer: (French for "sleep") a gable end window that pierces through the plane of a sloping roof surface to create usable space in the top floor or attic of a building by adding headroom. Example: Page 18	
Frontispiece: a portion of the façade of a building, usually a centred doorway that is slightly raised from the rest of the building, usually has extensive ornamentation. Frontispieces are usually Classical in design with white columned porches. Example: 163 Main Street, Page 38	
Gable: the triangular portion of a wall between the edges of a sloping roof. Example: 4 Ross Street, Page 21	
Hipped Roof: a roof where all sides slope downwards to the walls with no gables. Example: Page 23	
Iron Cresting: A decorative ornament along the top of a roof. Iron cresting was popular in the Baroque era and also in Italianate, Victorian, Second Empire and Queen Anne styles of architecture. Example: 213 Main Street, Page 25	

Keystones and Voussoirs: a voussoir is a wedge-shaped element used in building an arch. A keystone is the central stone that locks all the stones into position, allowing the arch to bear weight. A keystone is often enlarged and embellished. Example: Page 13	
Lancet Window: a tall, narrow window with a pointed arch at its top. Example: Erin United Church, Page 16	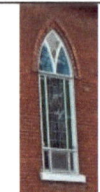
Quoin: masonry blocks at the corner of a wall, often a decorative feature, usually larger or of a different colour than the rest of the wall. Example: 214 Main Street, Page 25	
Verge board and Finial: also called bargeboards – hang from the projecting end of a roof and are often elaborately carved and ornamented. **Finial:** ornament added to the top of a gable, pinnacle, canopy or spire – a Gothic element. Example: 202 Main Street, Page 28	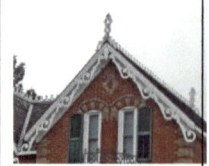

Building Styles

Style	
Gothic Revival, 1830-1890 – These decorative buildings have sharply-pitched gables with highly detailed verge boards, pointed-arch window openings, and dichromatic brickwork. It is a common style in Ontario. Example: 202 Main Street, Page 28	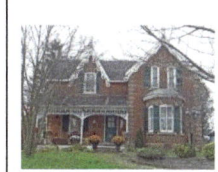
Italianate, 1850-1900 – A two story rectangular building with a mild hip roof, a projecting frontispiece, and generous eaves with ornate cornice brackets was the basis of the style; often there are large sash windows, quoins, ornate detailing on the windows, belvederes and wraparound verandahs. Italianate commercial buildings often have cast iron cresting and elegant window surrounds. Example: 213 Main Street, Page 25	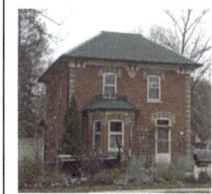
Vernacular/Traditional Mode 1638 - 1950 Influenced but not defined by a particular style, vernacular buildings are made from easily available materials and exhibit local design characteristics. Example: Page 31	
Victorian - In Ontario, a Victorian style building can be seen as any building built between 1840 and 1900 that doesn't fit into any of the other categories. It encompasses a large group of buildings constructed in brick, stone, and timber, using an eclectic mixture of Classical and Gothic motifs. Example: 214 Main Street, Page 25	

www.ingramcontent.com/pod-product-compliance
Lightning Source LLC
Chambersburg PA
CBHW041112180526
45172CB00001B/216